Design by Hana Anouk Nakamura Calligraphy by Nim Ben-Reuven

ISBN 978-1-4197-2717-7

Photographs © 2017 Georgianna Lane

Based on the book *Paris In Bloom* by Georgianna Lane, published by Abrams Image in 2017. Published in 2017 by Abrams Noterie, an imprint of ABRAMS. All rights reserved. No portion of this book may be reproduced, stored in a retrieval system, or transmitted in any form or by any means, mechanical, electronic, photocopying, recording, or otherwise, without written permission from the publisher.

Printed and bound in China 10 9 8 7 6 5 4 3 2 1

Abrams Noterie products are available at special discounts when purchased in quantity for premiums and promotions as well as fundraising or educational use. Special editions can also be created to specification. For details, contact specialsales@abramsbooks.com or the address below.